THE WRITER'S DRAWING BOOK

The Russians

SHAMBHALA
REDSTONE EDITIONS

Anton Chekhov, drawing on a letter to France Shekhtel, April 11, 1887

Shambhala Publications, Inc.
300 Massachusetts Avenue, Boston, Massachusetts 02115

Edited by Cathy Porter
Page design by Roxane Jubert, Studio Autrement
Cover design by Julian Rothenstein / Production by Tim Chester
Typesetting by Wayzgoose Phototypesetting / Printed by Tien Wah Press, Singapore

ISBN 1-57062-193-4

Ninochka by Anton Chekhov
Translation © 1994 by Paula Ross c/o Prometheus Books Inc. Amherst, New York 14228, USA

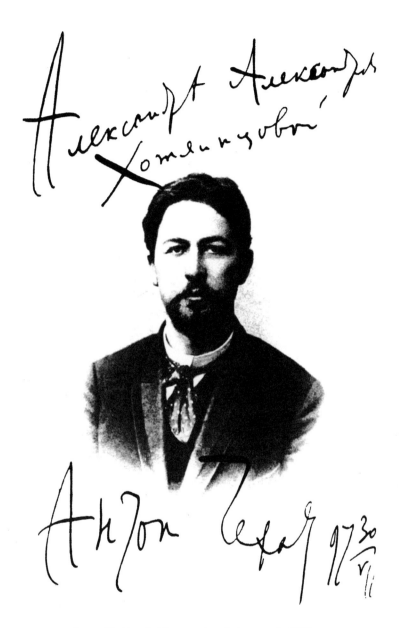

Anton Chekhov in Moscow, signed photograph, 1893

ANTON CHEKHOV

NINOCHKA

The door is opened quietly and my good friend Pavel Sergeevich Viklenev comes in. Although a young man, he appears old for his years and unwell. He is stooping, long-nosed and skinny. All in all he is not a good-looking man, and the sight of his dull, meek, unassuming physiognomy makes you want to take it in your hands and feel its soulful, soft-hearted doughiness.

'What is the matter?' I ask, gazing at his pale face and trembling lips. 'Are you ill? Or have you had another quarrel with your wife? You look terrible!'

Viklenev hesitates then clears his throat, and waving his hand he says: 'Please do something with Ninochka for me! Dear friend, such grief, I couldn't sleep all night! As you can see, I'm barely alive—I'm in an awful predicament! Other people endure insults, losses and sickness and it doesn't bother them at all, but I go to pieces over a trifle!'

'What happened?'

'It was nothing, just a petty family scene. I'll tell you all about it if you like. Last night my Ninochka didn't want to go out, she said she wanted to stay at home and spend the evening with me. Of course I was overjoyed. Most evenings she goes off to meet friends while I stay at home on my own, so you can imagine how delighted I was. But then you've never been married, so you can't imagine how warm and pleasant it feels to come home from work and find the person you live for . . . ' Viklenev expands for a while on the charms of family life, then wiping the perspiration from his brow he continues:

'So Ninochka wants to spend the evening with me. But you know me, I'm a dull person, I'm not smart. What sort of fun is it with me, forever busy with my soil filters and blueprints? I don't know how to play, or dance or have fun. I'm good for nothing, and Ninochka, as you know, is young and worldly. Youth has its rights, is that not true? So I begin showing her various things, pictures and so on, and I happen to remember some old letters I had stored away in my desk, some of them rather amusing. When I was a student I had some friends who wrote clever, witty things—you'd split your sides reading them! Anyway, I took these letters out of my desk and started reading them to Ninochka. I read one, then another, and a third—and suddenly I put the brakes on. In one of them appears the phrase 'Katenka sends her regards'. For a jealous wife such words are like a dagger, and my Ninochka is an Othello in a skirt.

'My wretched head is showered with questions: Who was this Katenka? What happened? What did it mean? I tell her Katenka was a sort of first love,

a student affair when I was young and green, to which no possible importance can be attached. Everyone has a Katenka in his youth, I say, you can't avoid it. But my Ninochka won't listen. She imagines god knows what, she goes into floods of tears, she grows hysterical.

"'You are vile and despicable to hide your past from me like this!" she shrieks. "Maybe you have another Katenka now, and you're hiding this from me too!"'

'I try over and over again to convince her that this is not true, but it is no use, male logic can never defeat the female mind. I go down on my knees and beg her forgiveness, I crawl on the floor before her, everything you can think of. She goes to bed in hysterics, while I sleep on the couch in my room. This morning things are no better, she just sulks and scowls and says she will go to her mother's—and she will too, you know what she's like!'

'Dear me, what a mess!'

'I simply can't understand women! However proud, young and pretty my Ninochka is, you couldn't write the sort of thing to her that you'd write to Katenka. But why is it so hard for her to forgive? All right, I'm guilty, but I begged her, I crawled on my knees before her, I even wept if you want to know!'

'Yes, women are truly a mystery!'

'Dear friend, you have some authority over Ninochka, she listens to you, she respects you. Go to her I beg you—speak to her, make her see reason. I am in agony, dear friend! If this goes on for one more day I shall be unable to endure it. Go to her, my friend!'

'But do you think it will help?'

'How can it not help? You and she have been friends almost since you were children—she trusts you! Oblige me by going to her!'

Moved by Viklenev's tearful entreaties, I put on my coat and drive off to his wife.

I find Ninochka engaged in her favourite activity, sitting on the couch with legs crossed doing nothing, gazing ahead with her pretty little eyes. On seeing me, she hops up from the couch and runs to me. Then she takes a quick look around, shuts the door and clings to my neck, light as a feather. (Do not imagine there is a misprint here. It has been a year since I have shared with Viklenev his marital obligations.)

'What have you been up to again, you minx?' I ask Ninochka, seating her beside me.

'Why, what's wrong?'

'You have been putting your husband through torture again. He came to me today with this story about Katenka!'

'Oh that. So he found somebody to complain to!'

'What happened?'

'Nothing really. Yesterday evening I felt cross and out of sorts because I had nowhere to go, so out of vexation I took on his Katenka. I was bored to tears—how can you explain tears of boredom to a man like him?'

'But my darling, that was cruel, it's inhuman! He is highly-strung, and you and your scenes make him more so!'

'Nonsense, he loves it when I'm jealous! Nothing is so entertaining as false jealousy. But let's not talk about it. I hate it when you start talking about my numbskull, he bores me enough as it is. Let's drink tea instead.'

'But please, you must stop tormenting him, it's too wretched for words. He describes family happiness so sincerely and so honourably, and he has such faith in your love that it fills one with awe. I'm sure you can control yourself somehow—lie, be nice . . . One word from you, and he's in heaven.'

Ninochka pouts and frowns, but all the same when Viklenev comes in a little later and looks timidly at me, she smiles happily and gazes at him fondly.

'You're just in time for tea!' she says to him. 'You always know when I'm at home, you're never late! What would you like, cream or lemon?'

Viklenev does not expect such a reception and he is deeply moved, kissing his wife's hand with feeling and embracing me. This embrace is so awkward and so out of place that both Ninochka and I blush.

'Blessed are the peacemakers!' prattles the happy husband. 'How did you manage to convince her? Because you are a man of the world, you have moved in high society, you know all the subtleties of a woman's heart. Pah, what a fool I am! Only one word is needed, and I'll say ten! You only need to kiss her little hand or something, but I don't do anything!' He bursts out laughing.

After tea Viklenev takes me to his study, grabs hold of one of my buttons and mutters: 'I don't know how to thank you, my dear fellow. You saw how much I suffered and tormented myself, and how happy I am now—it's more than I can bear! And this isn't the first time you've helped me out of trouble. My dear friend, don't deny me, I have something here, a little train which I made myself, I won a medal for it at an exhibition. Please do me the honour of taking it, as a token of gratitude and friendship!'

Naturally I try in every way possible to refuse, but Viklenev is implacable, and like it or not I am eventually forced to take his dear little gift.

Days pass, weeks, months, and sooner or later the damn truth becomes obvious to Viklenev in all its vile magnitude. Learning it by chance, he goes terribly pale, lies down on the couch and stares dully at the ceiling. He does not say a word, but the pain inflicted on his soul has to be released in some kind of action, and he tosses in agony from side to side on the couch. These movements somehow pull together his weak nature, and within a few days he has slightly recovered from this staggering news and approaches me. We are both embarrassed and unable to look each other in the face. For no reason at all I blurt out something about free love, marital egotism and resigning oneself to one's fate.

'No, no, it's not that,' he interrupts me abruptly. 'I understand all that perfectly. Nobody can be blamed for their feelings. It's another side of this I'm concerned with, the purely practical side. I don't know the right thing to do, dear friend, I know nothing about life or the customs of society, and this makes me a fool. You can help me, dear fellow. Tell me how I should behave with Ninochka. Should she continue to live with me, or do you think it would be preferable for her to live with you?'

It does not take us long to reach a mutually agreeable solution: Ninochka stays with Viklenev, and I visit her whenever it pleases me to do so. On these occasions Viklenev disappears into a corner room that was at one time a pantry. This room is a bit damp and dark and the entrance to it is through the kitchen, so you can shut yourself away exceedingly well and not annoy anyone.

1885

Translated by Paula Ross

1620–1682 ARCHPRIEST AVVAKUM

top
illustrated tailpiece for the end of *The Life of Archpriest Avvakum,
Written By Himself,* c. 1675

above
illustrated tailpiece for the end of the epistle to Tsar Alexei,
c. 1675

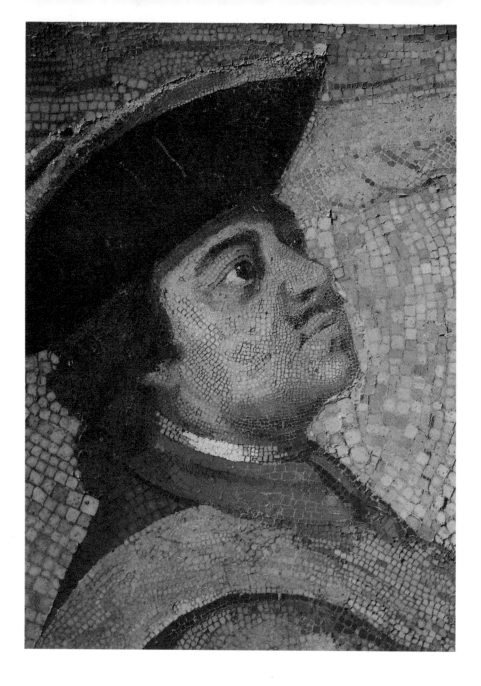

1711–1762 MIKHAIL LOMONOSOV

mosaic *The Battle of Poltava*, detail of Peter the Great

1769–1844 IVAN KRYLOV

illustration for a rough draft of the fable 'The Separation', 1812

1787–1855 KONSTANTIN BATYUSHKOV

sketches from the notebook *Various Observations*, 1807–1810

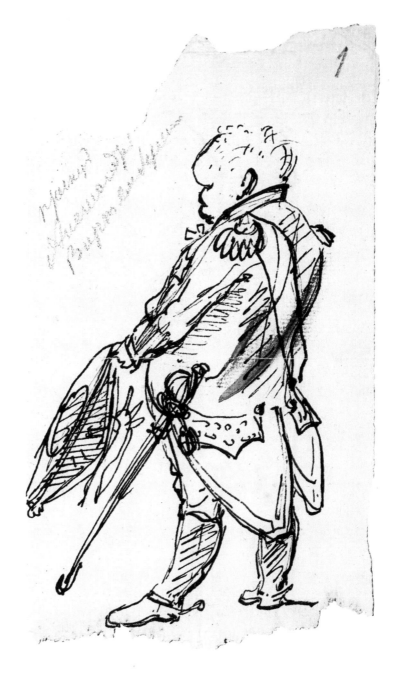

1797–1837 ALEXANDER BESTUZHEV-MARLINSKY

the Prince of Württemberg, early 1820s

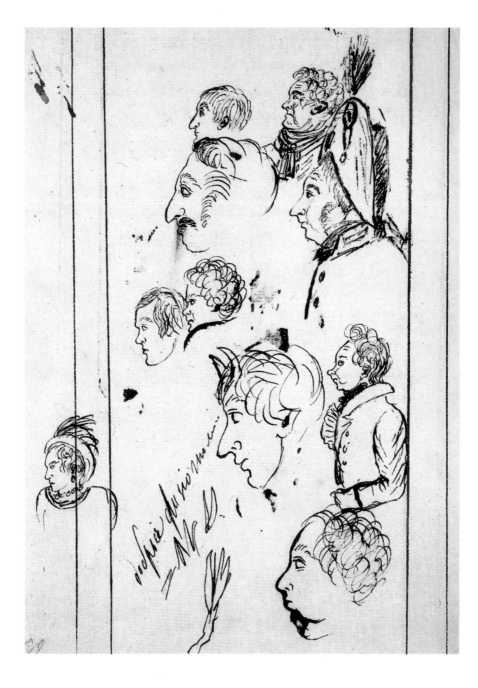

1798–1831 ANTON DELVIG

'Noteworthy physiognomies', 1826 (?)

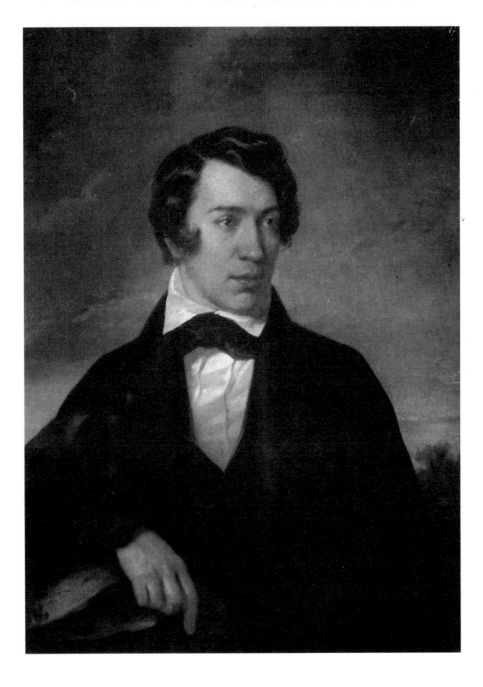

1804–1860 ALEXEI KHOMYAKOV

self-portrait, 1830s

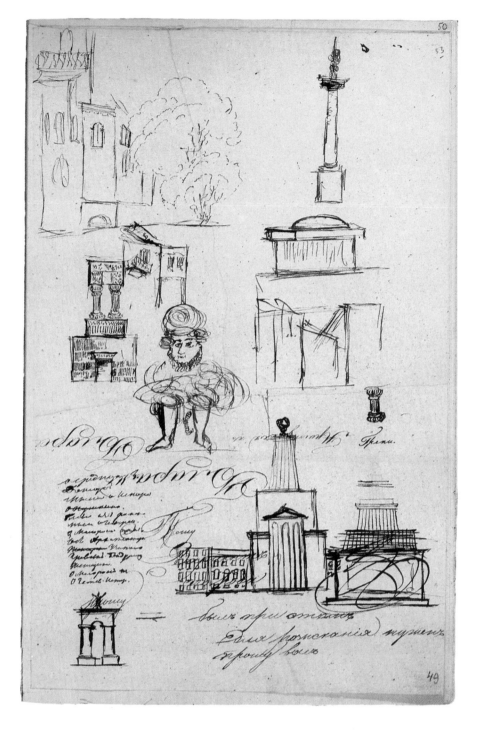

1809–1852 NIKOLAI GOGOL

architectural designs and plan for the miscellany *Arabesques*, 1834

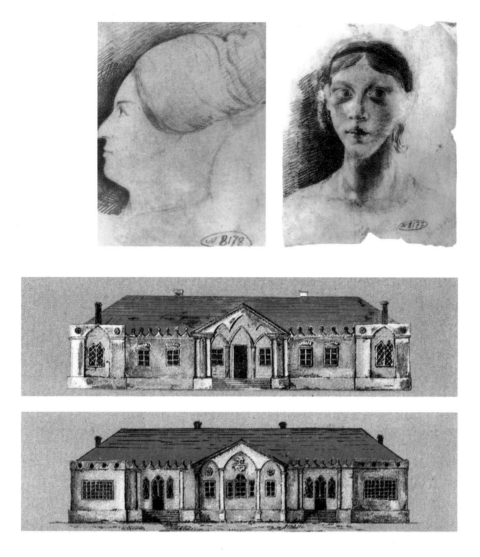

1809–1852 NIKOLAI GOGOL

top left
portrait of a woman, c. 1820

top right
portrait of a woman, c. 1820

above
façade of Gogol's house at Vasilevka
from the manuscript book *A Little of Everything*,
c. 1820

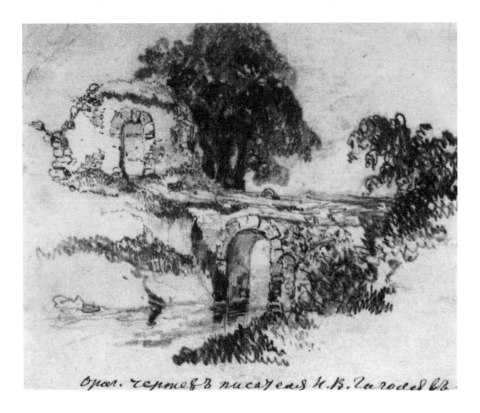

1809–1852 NIKOLAI GOGOL

top
Italian landscape, late 1830s

above
sketches for a portrait of Pushkin, 1838 (?)

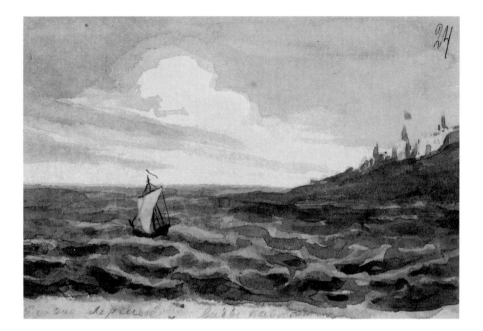

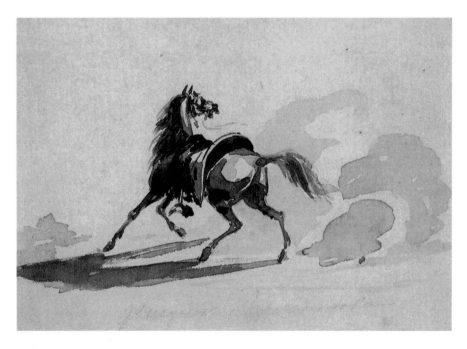

1814–1841 MIKHAIL LERMONTOV

top
'A lonely sail . . . ', 1828–1832

above
the race-horse, 1830s

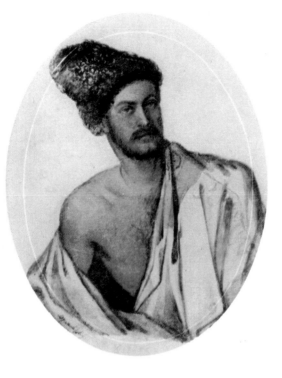

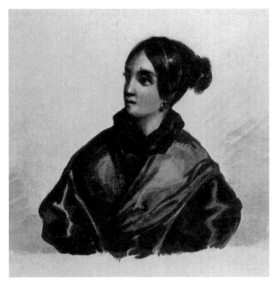

1814–1841 MIKHAIL LERMONTOV

top
portrait of A. Stolypin in Kurdish costume, 1841

above
portrait of V. Lopukhina, 1835 (?)

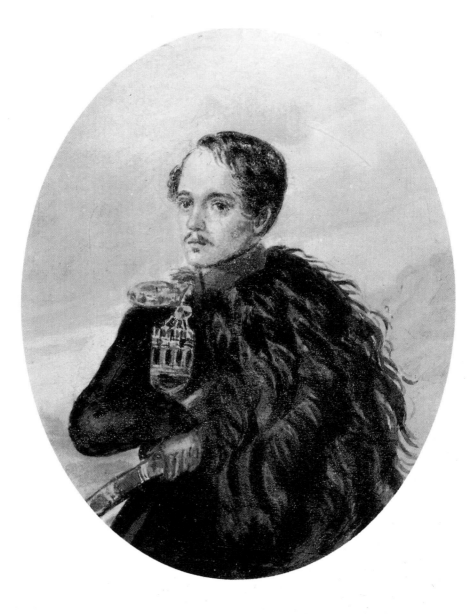

1814–1841 MIKHAIL LERMONTOV

self-portrait, 1837–1838

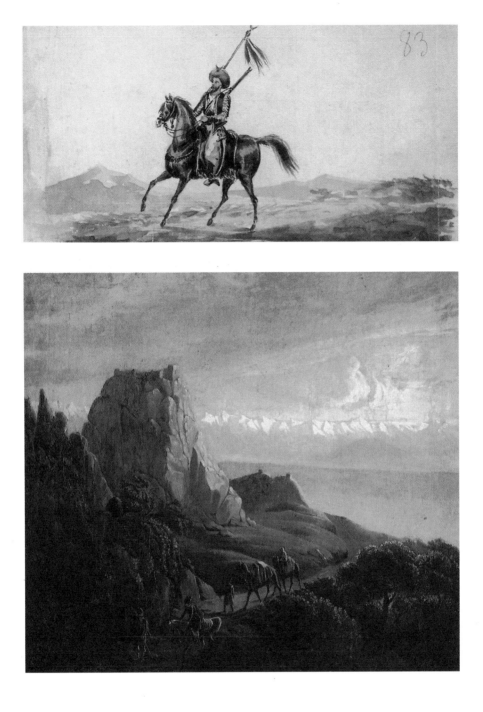

1814–1841 MIKHAIL LERMONTOV

top
a Caucasian highlander bearing a banner, 1836

above
Caucasian view with camels, 1837 (?)

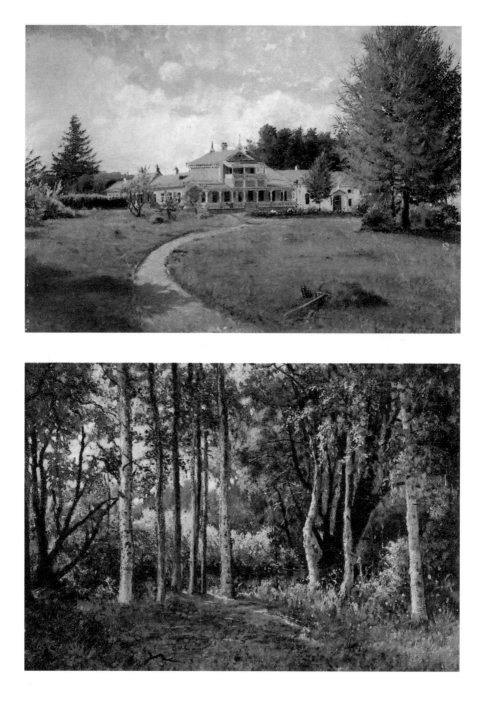

1819–1898 YAKOV POLONSKY

top
Ivan Turgenev's estate at Spasskoe-Lutovinovo, 1881

above
the park at Spasskoe-Lutovinovo, 1881

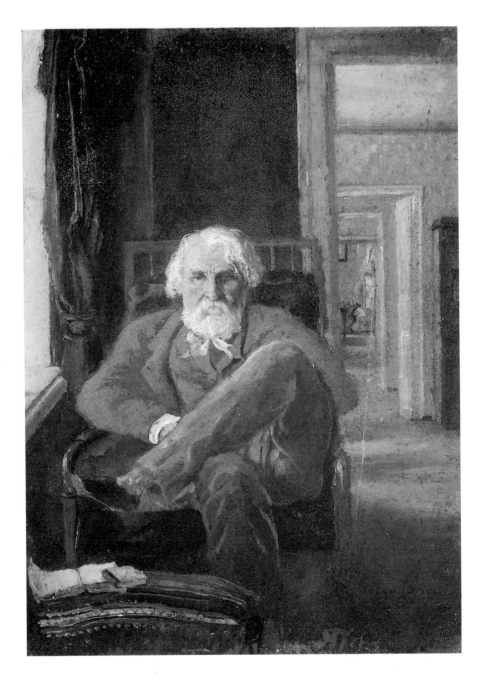

1819–1898 YAKOV POLONSKY

portrait of Ivan Turgenev, 1861

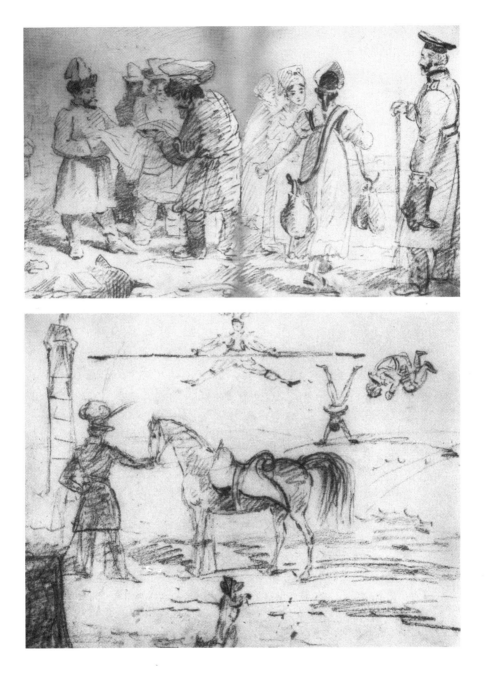

1787–1855 KONSTANTIN BATYUSHKOV

top
the fair, 1818 (?)

above
strolling acrobats, c. 1822

1787–1855 KONSTANTIN BATYUSHKOV

S Ponomaryova with her lady companion, 1818 (?)

1783–1852 VASILY ZHUKOVSKY

'Maman', 1840

1783–1852 VASILY ZHUKOVSKY

top
cemetery at Windsor, illustration for 'Elegy Written
in a Country Churchyard' by Thomas Gray, 1839

above
landscape, 1848–1849

1799–1837 ALEXANDER PUSHKIN

left
two self-portraits, 1826

right
portrait of Denis Davydov in the rough draft of
Excerpts from Onegin's Journey, 1825

1799–1837 ALEXANDER PUSHKIN

portrait of the poet Dmitry Venevitinov in the
rough draft of the introduction to chapters
eight & nine of *Evgeny Onegin*, 1830

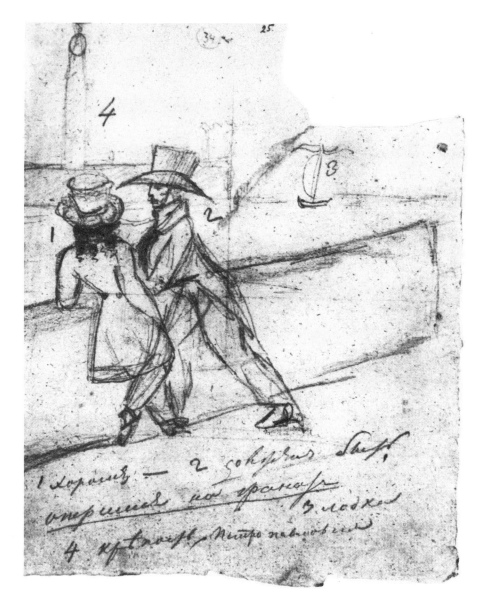

1799–1837 ALEXANDER PUSHKIN

Pushkin and Onegin, in a letter to L Pushkin, 1824

1799–1837 ALEXANDER PUSHKIN

top
drinking tea at the samovar, illustration to the story
'The Undertaker', from *Tales of Belkin*, 1830

above
the funeral procession, manuscript of the story
'The Undertaker', 1830

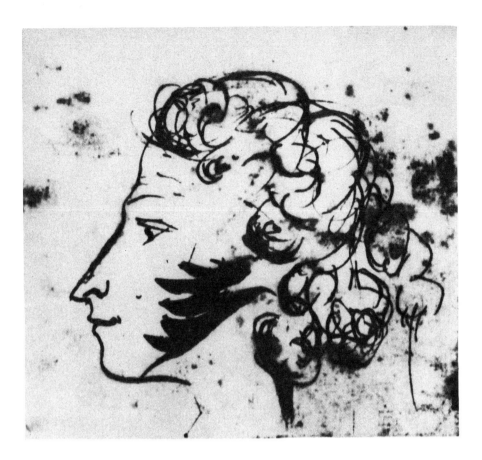

1799–1837 ALEXANDER PUSHKIN

self-portrait, said to be superior to all other portraits
of the poet by professional artists, 1827–1830

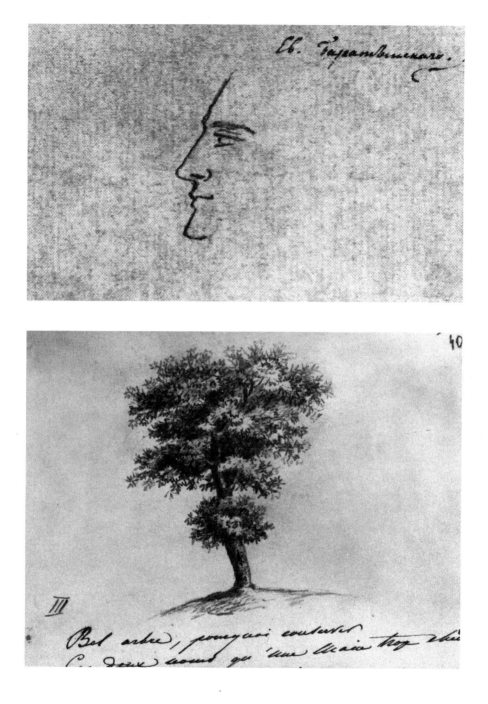

1800–1844 EVGENII BARATYNSKY

top
self-portrait from the manuscript of the long poem
'Do you wish to know the mysteries of love . . . ?, 1826

above
a tree, illustration to Evariste Parny's poem
'Bel arbre, pourquoi conserver . . . ', 1831

1805–1827 DMITRY VENEVITINOV

caricature from the draft of his poem
'The New Year of 1827', 1826

1821–1881 FYODOR DOSTOYEVSKY

sketches of various motifs, including portraits of
Raskolnikov and Porfirii Petrovich (?), from
the notebooks of *Crime and Punishment*, 1860–1866

1821–1881 FYODOR DOSTOYEVSKY

portrait of a man and exercises in calligraphy,
from the notebooks of *Crime and Punishment*, 1864–1866

1821–1881 FYODOR DOSTOYEVSKY

ornamental and architectural designs
from the notebooks of *Crime and Punishment*, 1864–1866

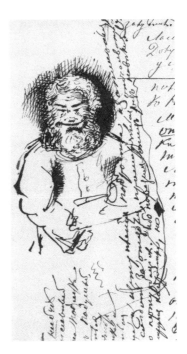

1821–1881 F Y O D O R D O S T O Y E V S K Y

left
profile of a man (perhaps Lambert),
notebooks of *A Raw Youth*, 1872–1875

right
Makar Ivanovitch (?),
notebooks of *A Raw Youth*, 1872–1875

1818–1883 IVAN TURGENEV

sketches from a draft of the article 'The Peasant and the Russian Economy', 1842

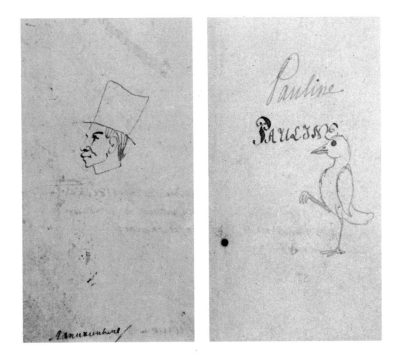

1818–1883 IVAN TURGENEV

doodles in the draft of the story
'Hamlet from the Shchigry District', 1848

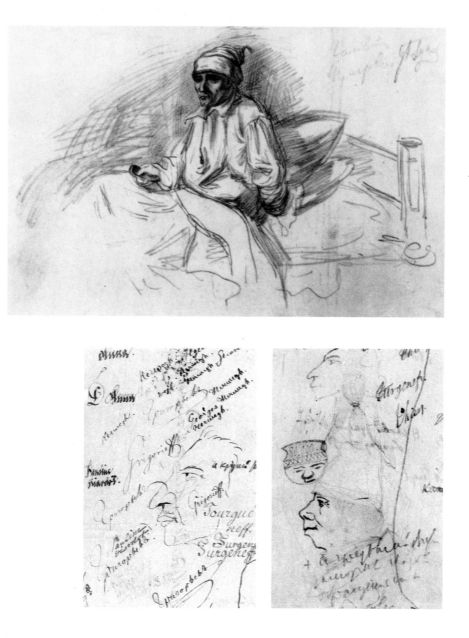

1818–1883 IVAN TURGENEV

top
illustration to the story 'Hamlet of the Schchigry District', late 1840s (?)

above
portrait of Apollon Grigorev in his night-club and a doodle in the draft
of the story 'Hamlet of the Shchigry District', 1848

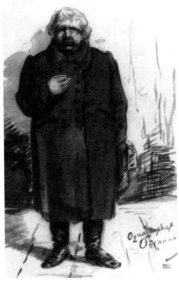

1818–1883 IVAN TURGENEV

top
self-portrait from a draft of 'The Bailiff',
one of the *Sportsman's Sketches*, 1847

above left
illustration to 'Kasyan from the Fair Mecha',
one of the *Sportsman's Sketches*, late 1840s

above right
illustration to 'Freeholder Ovsyanikov',
one of the *Sportsman's Sketches*, late 1840s

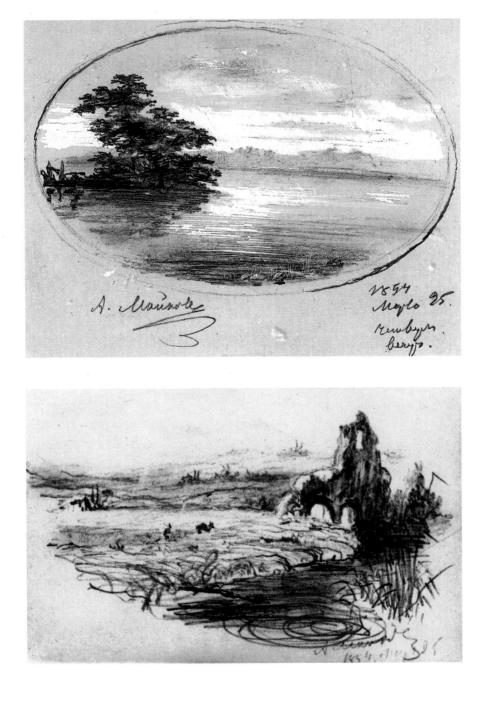

1821–1897 APOLLON MAYKOV

top
river landscape, 1854

above
ruins, 1854

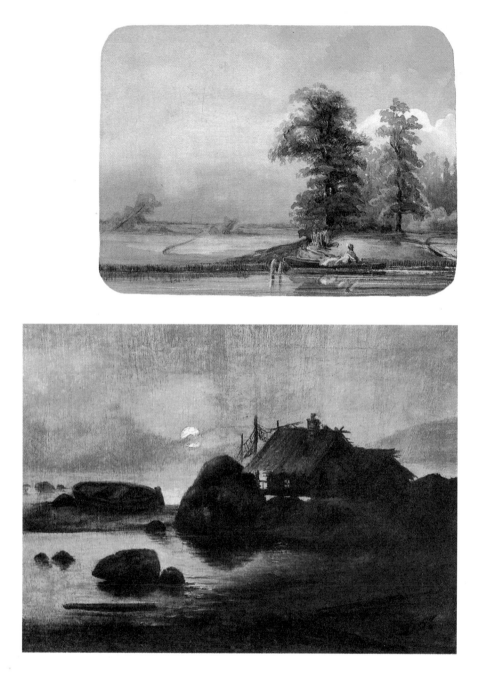

1822–1899 DMITRY GRIGOROVICH

top
the Dulebino estate, 1848

above
evening landscape, 1850s

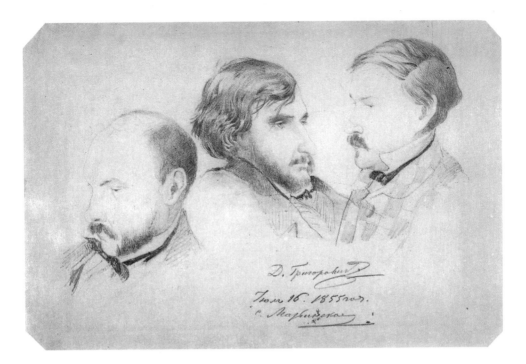

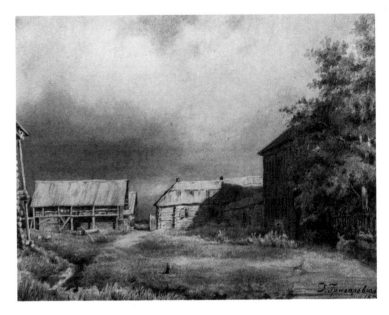

1822–1899 DMITRY GRIGOROVICH

top
portrait of Vasilii Botkin, Ivan Turgenev
and Alexander Druzhinin, 1855

above
the Dulebino estate, 1852

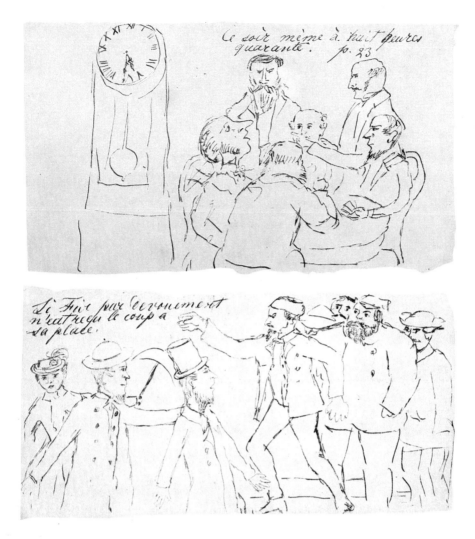

1828–1910 L E V T O L S T O Y

illustrations to Jules Verne's novel *Around the World in Eighty Days*,
which Tolstoy read to his children, 1873–1874

1828–1910 L E V T O L S T O Y

top
rough drawings intended for his ABC, 1870s

above
drawing for a draft of the first version of *War and Peace*, 1860s

1884–1967 SERGEI GORODETSKY

portrait of the poet Velimir Khlebnikov, 1920

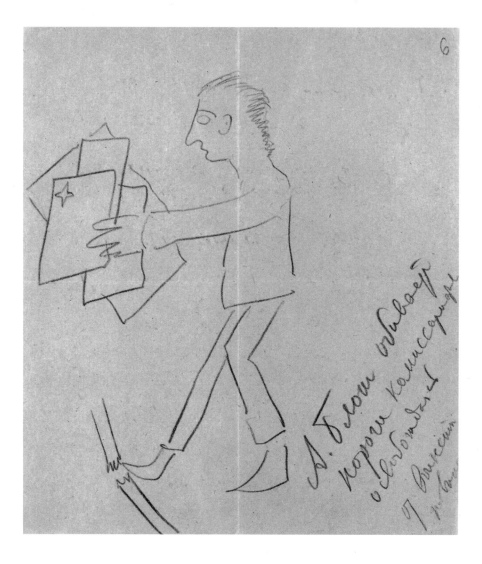

1880–1921 ALEXANDER BLOK

self-caricature, 'Blok knocking at the doors of
the recruitment offices, seeking exemption from military service', 1917

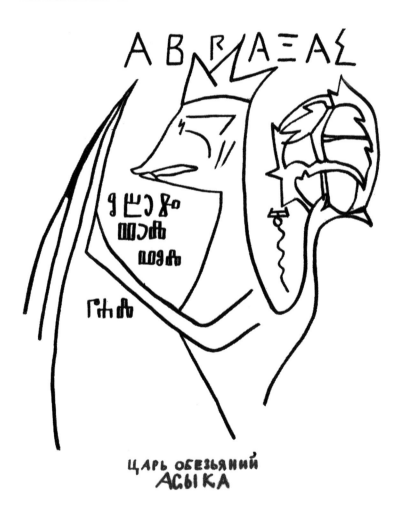

1877–1957 ALEXEI REMIZOV

top
pages from the manuscript book *What tobacco is*, 1870s

above
Asyka, King of the Monkeys (humorous society invented
by the author and made up of his friends, 1930s (?)

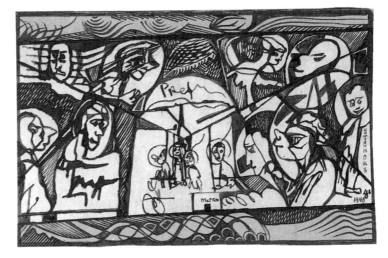

1877–1957 ALEXEI REMIZOV

top
jacket sketch for the book *Drawings of Writers*, 1937

above
drawing from the *Graphic Journal of the Occupation*, 1940–1943, Paris, 1940

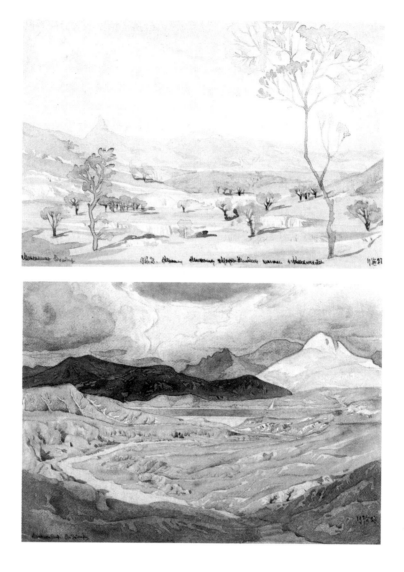

1877–1932 MAXIMILIAN VOLOSHIN

top
Koktebel, on the Crimean coast, water-colour, 1927

above
landscape, water-colour, 1927

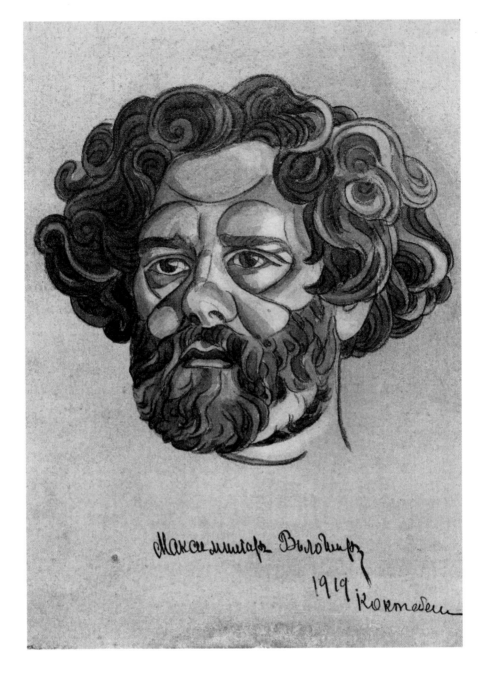

Максимиліанъ Волошинъ
1919 Коктебель

1877–1932 MAXIMILIAN VOLOSHIN

self-portrait, 1919

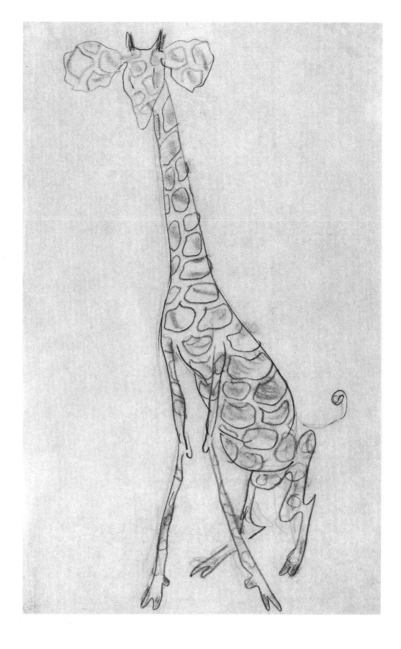

1893–1930 VLADIMIR MAYAKOVSKY

giraffe, 1913

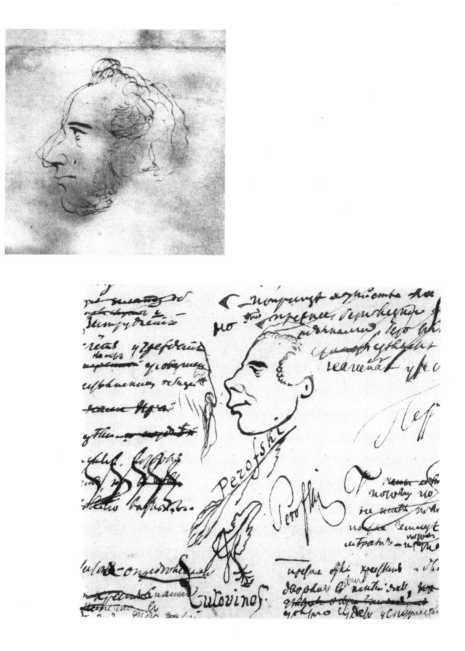

1818–1883 IVAN TURGENEV

top
portrait of a man, 1836

above
portrait of L Perovsky, rough draft of the article
'The Peasant and the Russian Economy', 1842

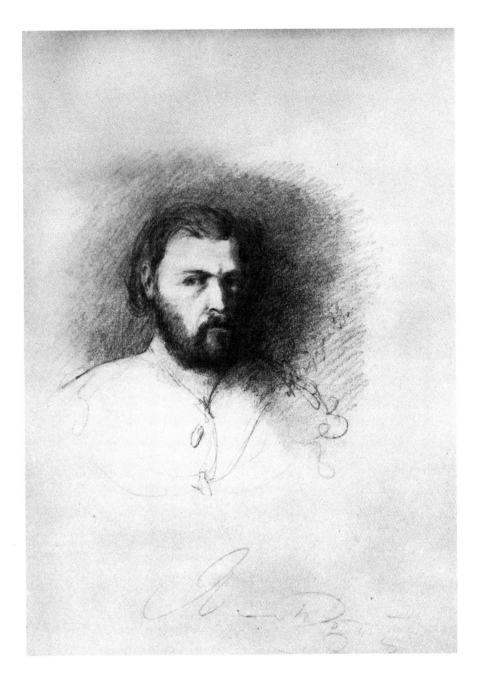

1819–1898 Y A K O V P O L O N S K Y

self-portrait, 1862

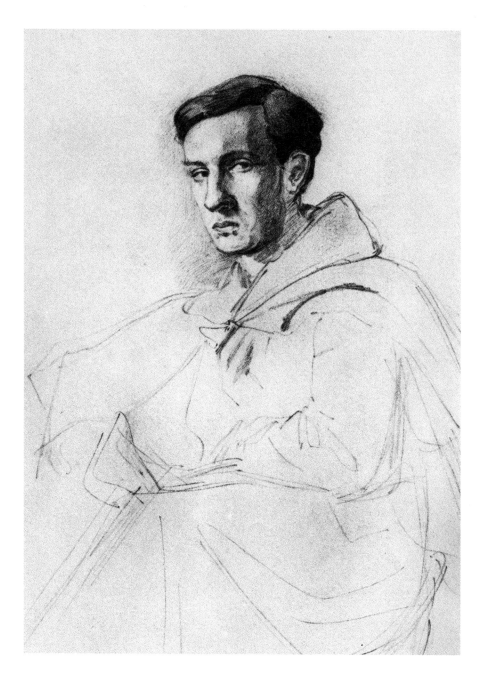

1822–1899 DMITRY GRIGOROVICH

self-portrait, 1840s

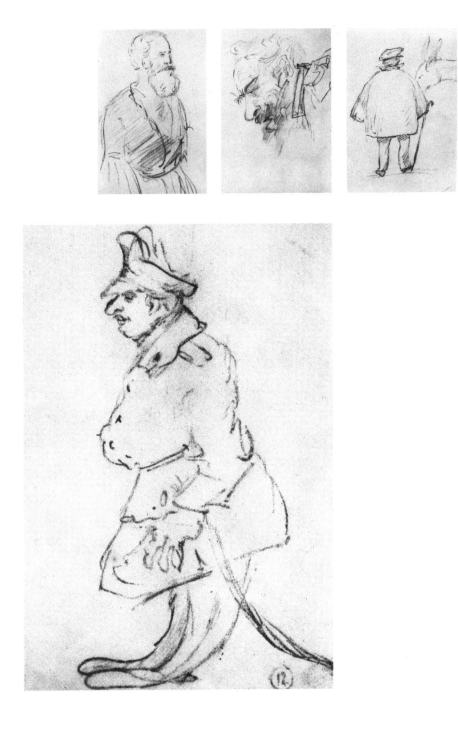

1828–1910 LEV TOLSTOY

top
old man, head of an old man, male silhouette with donkey,
the Caucasian notebook, 1852

above
officer, the Caucasian notebook, 1852

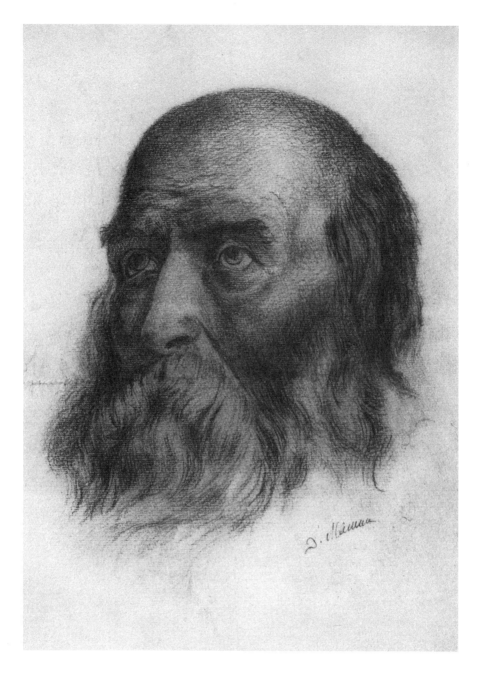

1852–1912 DMITRY MAMINY-SIBIRYAK

portrait of an old man, 1901 (?)

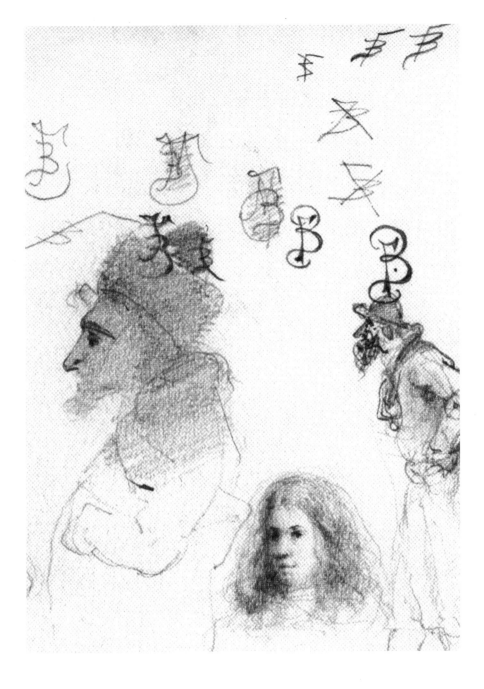

1855–1888 V S E V O I O D G A R S H I N

sketches, c. 1870

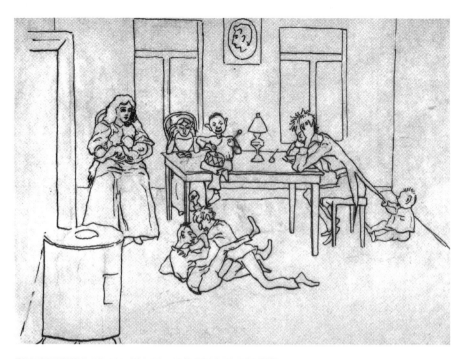

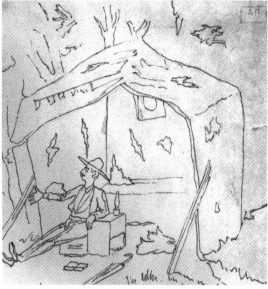

1871–1919 LEONID ANDREEV

top
caricature of the writer with his family, 1897

above
self-caricature of the writer in his tent, 1897

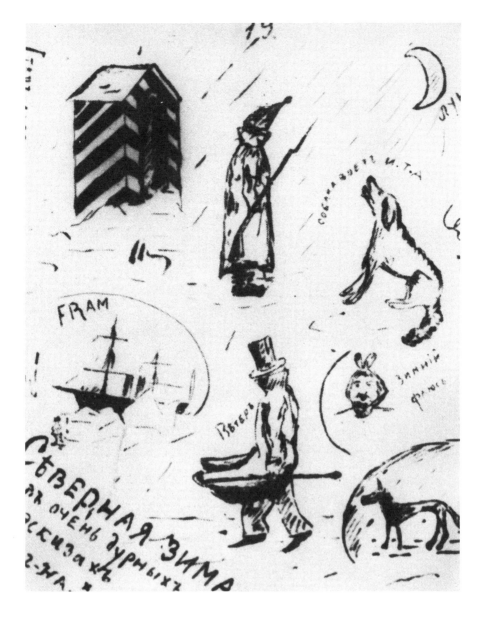

1880–1921 A L E X A N D E R B L O K

'northern winter', drawing from the journal *The Messenger*, 1897

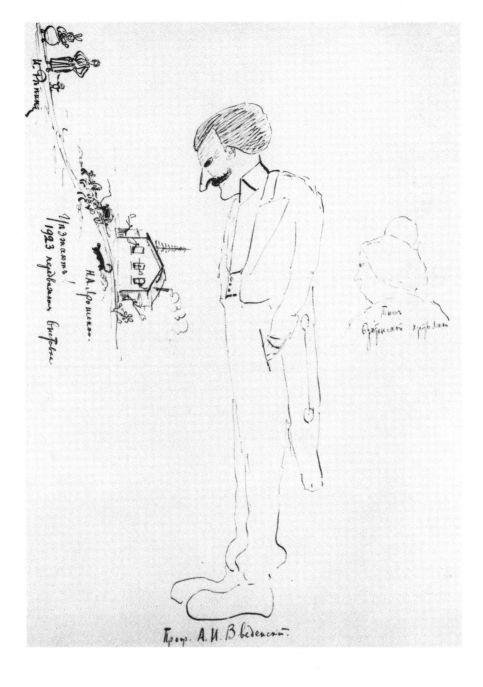

1880–1921 A L E X A N D E R B L O K

caricature of Professor Vedensky and the Peredvizhniki artists
(the 'Wanderers'). On the right, a typical peasant
woman from Brittany, c. 1910

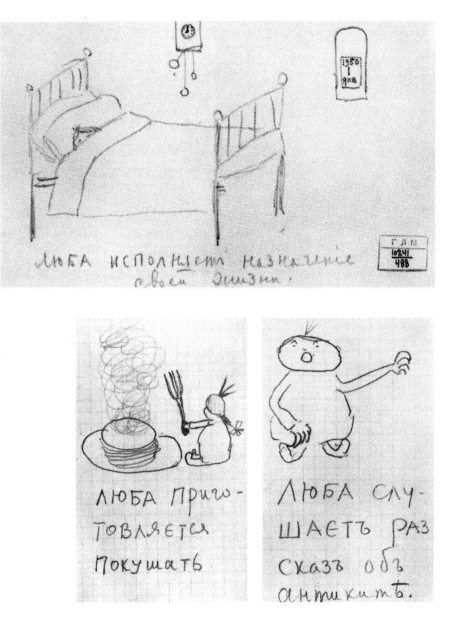

1880–1921 A L E X A N D E R B L O K

satirical drawings of the poet's wife,
Lyuba Dmitrevna, née Mendeleeva, c. 1900–1910

top
Lyuba fulfilling her destiny

above left
Lyuba preparing to eat

above right
Lyuba listening to a story about the old times

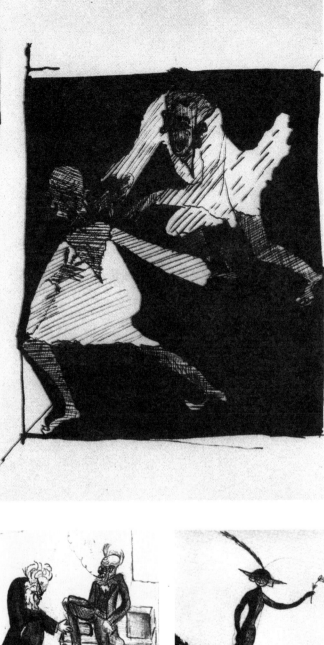

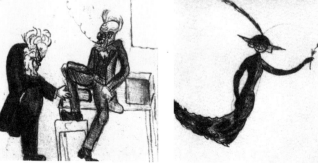

1880–1934 A N D R E I B I E L Y

top left
Nikolai Apollonovich Ablevkhov, one of the heroes
of the novel *St Petersburg*, c. 1910

top right
the Ablevkhovs, father and son, illustration to the novel *St Petersburg*

above left
the Korobkin brothers, illustration to the novel *Masks*, 1920–1930

above right
Eleonora Titeleva, illustration to the novel *Masks*, 1920–1930

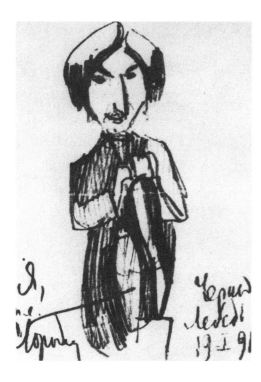

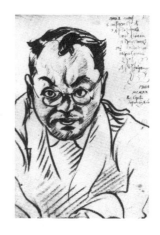

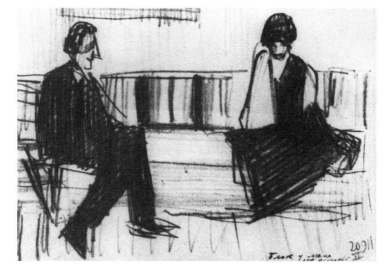

1884 1967 SERGEI GORODETSKY

top left
self-caricature, 1910

top right
portrait of Alexei Remizov, 1920

above
'Blok on my island', A Blok and A Gorodetskaya, 1911

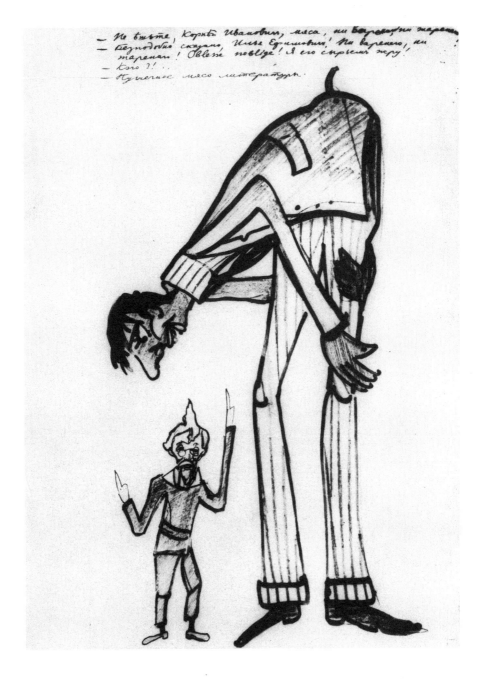

1884–1967

SERGEI GORODETSKY

caricature of the painter Repin and the writer Chukovsky,
manuscript of the comic review *Okolo Kuokkala*
(around about Kuokkala), 1914

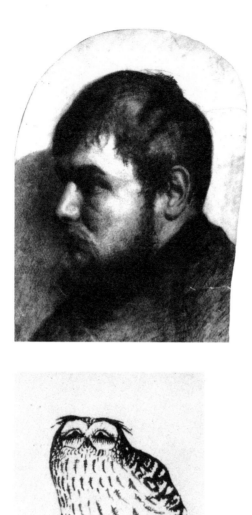

1885–1922 VELIMIR KHLEBNIKOV

top
portrait of a cab driver, early 1900s

above
owl, early 1900s

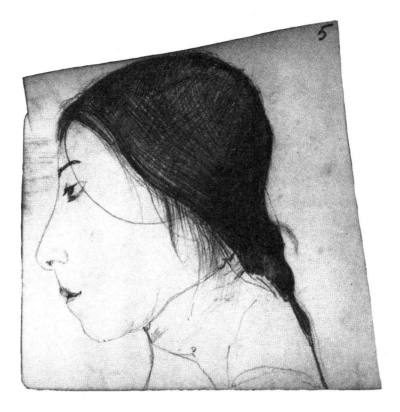

1885–1922 VELIMIR KHLEBNIKOV

top
portrait of V Khlebnikov, 1910–1912

above
self-portrait, 1909

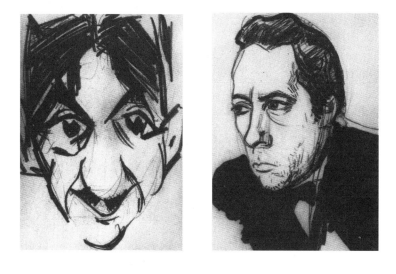

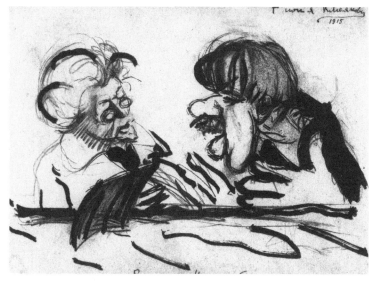

1893–1930 VLADIMIR MAYAKOVSKY

top left
caricature of the painter G Yakulov, 1918 (?)

top right
portrait of Velimir Khlebnikov, 1916

above
caricature of the painter Repin and the writer Chukovsky, 1915